CUBISM

Linda Bolton

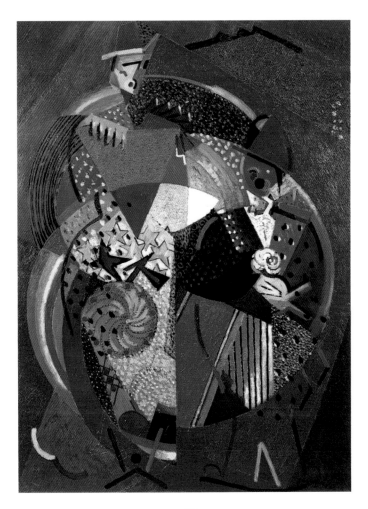

Belitha Press

First published in Great Britain in 2000 by

Belitha Press Limited
A member of **Chrysalis** Books plc
64 Brewery Road, London N7 9NT

Paperback edition first published in 2003

Editor Susie Brooks
Designer Helen James
Picture Researcher Diana Morris
Educational Consultant Hester Collicutt

ISBN 1 84138 108 X (hb)
ISBN 1 84138 773 8 (pb)

British Library Cataloguing in Publication Data
for this book is available from the British Library.

Printed in China

Picture Credits:

Front cover: Jean Metzinger, The Cat, c.1915. Private Collection. Photo Bridgeman Art Library. © DACS, London. 1: Albert Gleizes, The Clowns, 1917. Private Collection. Photo Giraudon/Bridgeman Art Library. © DACS, London. 4: Paul Cézanne, Le Lac d'Annecy, 1896. The Courtauld Institute Galleries, London. Photo Bridgeman Art Library. 5: Fernand Léger, Mechanical Elements, 1918-23, Kunstmuseum, Basle. Photo Peter Willi/Bridgeman Art Library. © DACS, London. 6: Eadweard Muybridge, Athlete. Running. Photographed synchronously from two points of view, 1887. Photo AKG London. 7t: Bakuba mask from ancient Central Congo Kingdom. The British Museum, London. Photo Bridgeman Art Library. 7b: Pablo Picasso, Les Demoiselles d'Avignon, 1907. The Museum of Modern Art, New York. Acquired through the Lillie P. Bliss Bequest. Photo © 1999 The Museum of Modern Art, New York. © Succession Picasso, Paris/DACS, London. 8: Pablo Picasso, The Factory at the Village of Horta de Ebro, 1909. Hermitage, St. Petersburg. Photo Bridgeman Art Library. © Succession Picasso, Paris/DACS London. 9t: Pablo Picasso, Ma Jolie, 1911-12. The Museum of Modern Art, New York. Acquired through the Lillie P. Bliss Bequest, Photo © The Museum of Modern Art, New York. © Succession Picasso, Paris/DACS, London. 9b: Pablo Picasso, Harlequin, 1915. The Museum of Modern Art, New York. Acquired through the Lillie P. Bliss Bequest. Photo © The Museum of Modern Art, New York. © Succession Picasso, Paris/DACS, London. 10: Georges Braque, The Viaduct at Estaque, 1908. Musée National d'Art Moderne, Paris. Photo Peter Willi/Bridgeman Art Library. © DACS, London. 11t: Georges Braque, The Sacré-Coeur of Montmartre, 1910. Donation Geneviève and Jean Masurel, 1979, Musée d'Art Moderne de Lille Métropole, Villeneuve d'Ascq. Photograph Muriel Anssens. © DACS, London. 11b: Georges Braque, Still Life with a Violin and a Pitcher, 1910. Öffentliche Kunstsammlung, Basle. Photo Peter Willi/Bridgeman Art Library. © DACS, London. 12: Fernand Léger, Soldiers Playing Cards, 1917. Kroller-Müller Museum, Otterlo. © DACS, London. 13t: Fernand Léger, The Town, (1st stage), 1919. Galerie Daniel Malingue, Paris. Photo Bridgeman Art Library. © DACS, London. 13b: Fernand Léger, The Tug Boats, 1920. Musée de Grenoble. Photo Peter/Willi/Bridgeman Art Library. © DACS, London. 14: Juan Gris, Portrait of Picasso, 1912. Art Institute of Chicago. Photo Lauros-Giraudon/Superstock. 15t: Juan Gris,

Fantomas, 1915. Chester Dale Fund, National Gallery of Art, Washington DC. 15b: Juan Gris, Landscape at Céret, 1913. Moderna Museet, Stockholm. 16: Robert Delaunay, The Eiffel Tower, 1910-11. Kunstmuseum, Basle. Photo AKG London. © L & M Services, Amsterdam. 17t: Robert Delaunay, Homage de Bleriot, 1914. Kunstmuseum, Basle. Photo Hans Hinz-Artothek. © L & M Services, Amsterdam. 17b: Robert Delaunay, Window, Study for "Two Windows", 1912. Musée National d'Art Moderne, Paris. Photo Peter Willi-Artothek. © L & M Services, Amsterdam. 18: Albert Gleizes, Landscape, 1911. Musée National d'Art Moderne, Paris. Photo Peter Willi/Bridgeman Art Library. © DACS, London. 19t: Albert Gleizes, The Bridges of Paris, 1912. Museum Moderne Kunst, Stiftung Ludwig, Vienna. © DACS, London. 19b: Albert Gleizes, The Clowns, 1917. Private Collection. Photo Giraudon/Bridgeman Art Library. © DACS, London. 20: Jean Metzinger, The Cat, c.1915. Private Collection. Photo Bridgeman Art Library. © DACS, London. 21t: Jean Metzinger, Tea Time (Woman with Teaspoon), 1911. Philadelphia Museum of Art. Photo Graydon Wood. © DACS, London. 21b: Jean Metzinger, The Knitter, 1919. Musée National d'Art Moderne, Paris. Photo Peter Willi/Bridgeman Art Library. © DACS, London. 22: Roger de la Fresnaye, Le Cuirassier, 1910-11. Musée National d'Art Moderne, Paris. 23: Roger de la Fresnaye, The Conquest of the Air, 1913. The Museum of Modern Art, New York. Mrs Simon Guggenheim Fund. Photo © 1999 The Museum of Modern Art, New York. 24: Marcel Duchamp, Nude Descending a Staircase, No 2, 1912. Philadelphia Museum of Art. Photo AKG London. © DACS, London. 25: Marcel Duchamp, Portrait of Chess Players, 1911. Philadelphia Museum of Art, Louise & Walter Arensberg Collection. Photo Bridgeman Art Library. © DACS, London. 26: Jacques Villon, Young Woman, 1912. Philadelphia Museum of Art, Louise & Walter Arensberg Collection. © DACS, London. 27: Jacques Villon, A Woman, 1913. Private Collection. Photo Bridgeman Art Library. © DACS, London. 28t: Gino Severini, Ballerina in Blue, 1912. Mattioli Collection, Milan. Photo Bridgeman Art Library. © DACS, London. 28b: Natalia Goncharova, The Cyclist, 1913. The Hermitage, St. Petersburg. Photo Bridgeman Art Library. 29t: Umberto Boccioni, Unique Forms of Continuity in Space, 1913. Mattioli Collection, Milan. Photo Bridgeman Art Library. 29b: Kasimir Malevich, The Aviator, 1914. The Hermitage, St Petersburg. Photo Bridgeman Art Library.

CONTENTS

Useful words are explained on page 30.
A timeline appears on page 31.

CUBIST CLUES

**Would you draw a face with too many noses, or a
dancer with dozens of legs? Can you paint a landscape in
cones, cubes and spheres, or a building in disjointed pieces?
The Cubists did! They pictured the world as a jigsaw of
geometric shapes – and they created a stir. But why did
they do it? What inspired this baffling art revolution?**

You can tell how the term Cubism came about
– the paintings are full of cuboid shapes! The
style sprung from a comment made by French
painter Paul Cézanne. 'All nature is made up of
the cone, the cylinder and the sphere', he said.

The Cubists liked this idea. They decided to focus
on the forms Cézanne talked about – to paint the
world as if it really was made of geometric shapes!
At first people were shocked by their work. It was
unrealistic and quite unlike traditional art styles.

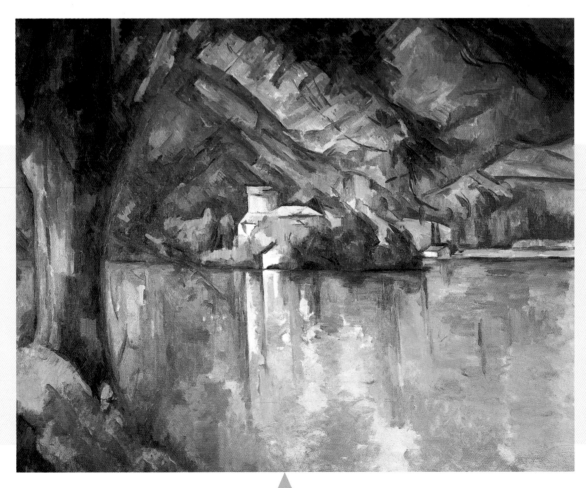

The Cubists were interested in the way we look at the world. They noticed how things take on different shapes when we see them from different viewpoints. Why not show things from several angles at once? By painting many views of the same object together in one picture, the Cubists found a new way of capturing the 3-D world on a flat artist's canvas.

Because of their multiple viewpoints, Cubist paintings often look as if they've been broken into pieces and rearranged. The effect is explosive and energetic – just like the fast-changing world the Cubists were living in. Many of these artists chose to paint modern subjects, such as engineering and flight. Others used the new style to show traditional themes in a revolutionary way.

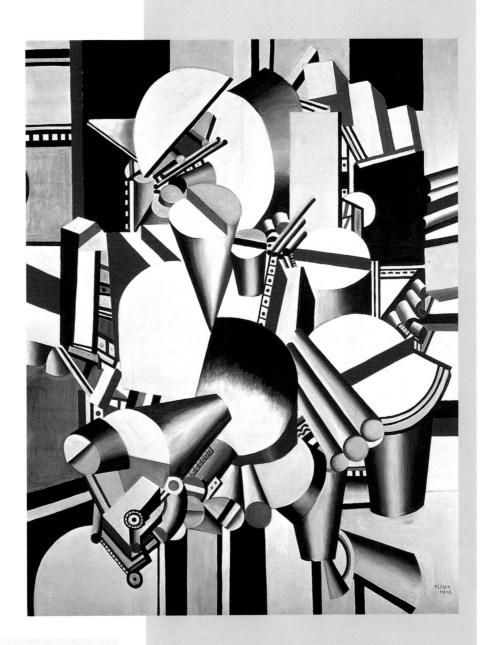

PAUL CÉZANNE
Lake at Annecy

1896, oil paint on canvas

The cones, cylinders and spheres Cézanne spoke of are not always obvious in his own paintings. He simply wanted to achieve a solid structure and harmonious composition. In this lakeside scene he has broken down colour into blocks, balancing lights and darks. He has simplified nature, creating a calm and orderly image.

FERNAND LÉGER
Mechanical Elements

1918–23, oil paint on canvas

The Cubists admired the solid structure of Cézanne's art. Léger said, 'Cézanne taught me to love forms and volumes, he made me concentrate on drawing.' Here Léger has exaggerated the subtle shapes he saw in the older artist's paintings to create a modern image which looks like a robotic machine.

Paris was the centre of the art world at the turn of the twentieth century, and this was where Cubism first made its mark. Picasso and his friends lived and worked there. They learnt a great deal from important art exhibitions held in the city, including a retrospective show of Cézanne's paintings in 1907. Soon after this, they began to exhibit their own work too.

Scientific developments were also exciting to the Cubists. Photography, invented in the late 1830s, was becoming more advanced. Painters no longer needed to create accurate recordings of people or events – the camera could do that. Photos could also capture moving objects. The Cubists were fascinated by movement. They tried to create a feeling of action in their work.

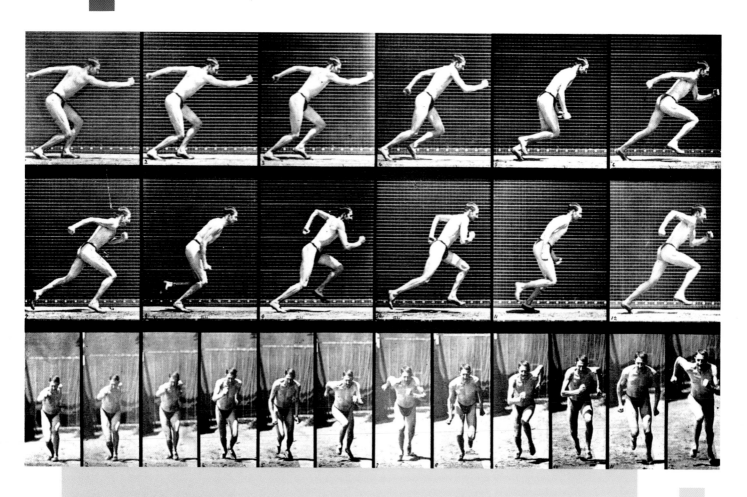

EADWEARD MUYBRIDGE
Athlete Running

1887, photographic sequence

This is a series of pictures taken by the American photographer Eadweard Muybridge. He made sequences of photos recording people moving. These enabled artists to see figures from many angles and in many positions. It helped them to study the shapes the movement made.

BAKUBA MASK from Ancient Central Congo Kingdom c1900, wood

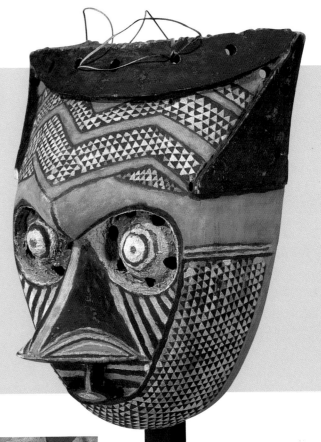

Many Cubist painters were influenced by African art. They thought the primitive style was much more powerful than most western European paintings and sculptures. Picasso collected African masks such as this one. He liked their bold shapes and raw, striking energy. He saw in them a strong and different beauty which he tried to capture in his own work.

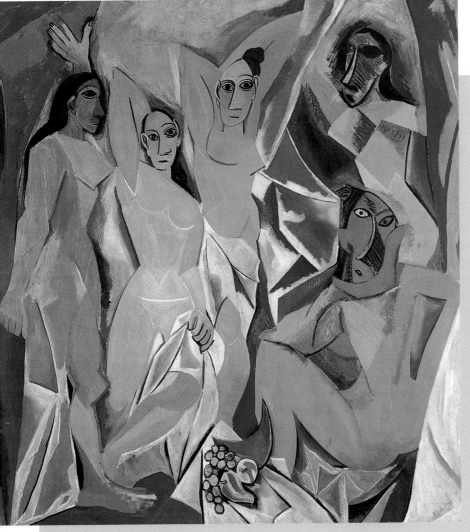

PABLO PICASSO Les Demoiselles d'Avignon

1907, oil paint on canvas

This painting is often seen as the starting point of Cubism – and of modern art itself. The faces of the two women on the right show how closely Picasso drew from African carvings. His figures look distorted, primitive and strange. He didn't want to paint a pretty picture. That was old-fashioned. He didn't want to make his picture look real. That's what photos were for. Picasso wanted to create a new kind of art for a new age.

PABLO PICASSO
1881–1973

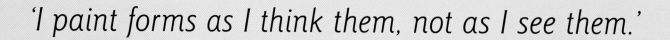

'I paint forms as I think them, not as I see them.'

Pablo Picasso is probably the most famous artist of the twentieth century. He was born in Spain, where he began his training as an artist. Picasso was the son of an art teacher, and could draw and paint brilliantly from early boyhood.

At the age of 19 Picasso moved to Paris where he experimented with many art styles. He soon took an interest in African and ancient Spanish art, as well as the paintings of Paul Cézanne. This led him to pioneer the revolutionary Cubist style.

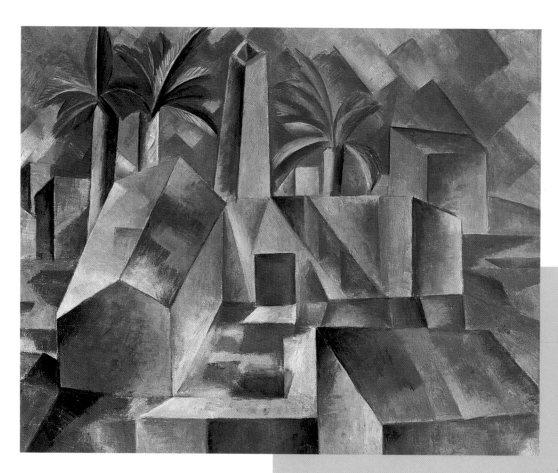

The Factory at the Village of Horta

1909, oil paint on canvas

Picasso revisited Spain many times during his first few years of living in Paris. He missed his native country and the hot, sunny weather there.

He painted this factory scene on a return visit in the summer of 1909. The buildings, palm trees and clouds are all reduced to simple geometric forms. Picasso has painted the cuboid shapes in contrasting shades of orange and grey, so they stand out in different ways. The well-balanced 3-D effect is like that of a gemstone – an object with many planes.

Ma Jolie

1911, oil paint on canvas

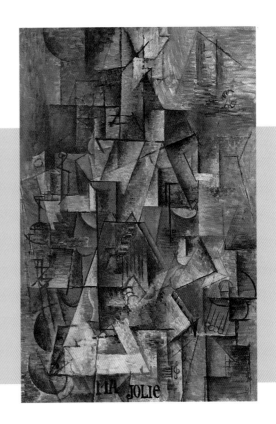

The title of this painting means 'my pretty one' in French. It is a portrait of a woman known as Eva, with whom Picasso had fallen in love. *Ma Jolie* was also the title of a song that was popular in 1911. There's a treble clef sign which reminds us of music, and other shapes which look like parts of a guitar. Perhaps Picasso wanted to create a picture that made us think of the song, rather than paint an image that our eyes would recognize. It's difficult to make out any object clearly in this painting. Everything is broken into pieces and rearranged.

PERSONALITY PIECES

Why not create a Cubist picture that makes you think of someone you know? Take a photo of them, or paint a portrait, then cut it up and rearrange the image on a new piece of paper. Add some cut-up pictures of objects which give clues about their personality and interests.

Harlequin

1915, oil paint on canvas

Picasso said this work was the best he'd ever done. It is quite different from his earlier paintings. Everything is simplified – it looks like a series of flat, cut-out shapes. The harlequin is a diamond-patterned rectangle with a slice cut out of it to form two legs. The head and neck are like a ball on a stick, with a circle representing a single eye. Behind the figure are more simple forms. Picasso has only put in the details he wants us to see. The image looks more like a pattern than a person standing in a room.

GEORGES BRAQUE 1882–1963

Georges Braque learnt to paint in his family decorating firm. Later he turned to fine art and moved to Paris, where he worked so closely with Picasso that sometimes their work is hard to tell apart. Later, even the artists themselves struggled to remember who had painted what!

In 1912 Braque became the first modern artist to use collage, and Picasso soon followed suit. But in 1914 Braque was called up to fight in the First World War. Afterwards he painted very differently from Picasso. The war is often seen to mark a turning point in the Cubist movement.

Viaduct and Houses at L'Estaque

1908, oil paint on canvas

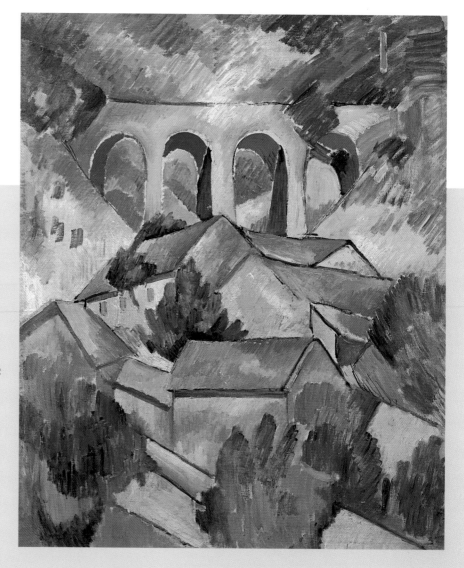

The painter Henri Matisse spoke of this painting as being entirely made up of little cubes. You can see why. The landscape is not shown in a realistic way, but broken into bold cubic shapes. It's clear that Braque was influenced by Cézanne, who had lived and worked in this part of southern France. We can also see similarities with Picasso's *Factory at the Village of Horta*, which was painted the following year.

The Sacré-Coeur
1910, oil paint on canvas

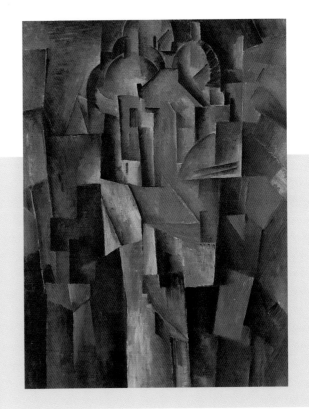

The Sacré-Coeur is a famous hilltop church in Paris. Like the Eiffel Tower, it can be seen from many places in the city below. It is one of the great Parisian landmarks. Here we can see the domes of the church at the top of the painting. The building is chopped into geometric shapes that seem to be disjointed. The bold patches of steely sky appear as solid as the stone itself. Braque's dull greys and browns show that he was more interested in form than in colour.

A NEW VIEW
Think about your favourite view. How would paint it if you were a Cubist? Try simplifying the scene into bold geometric shapes, such as cones, cylinders, spheres and cuboids. Limit your colours to greys and browns, like Braque.

Still Life with Violin and Pitcher
1910, oil paint on canvas

Braque and Picasso painted many still lifes of musical instruments and vessels. The things which stand out most clearly in this picture are the strings and body of a violin. But what we see is disjointed, as though it has been broken and rearranged, or viewed through rippled glass. The pitcher blends into the background as though the space around it is as important as the object itself. Again Braque has limited his colours so that the angular shapes merge in a confusing way.

FERNAND LÉGER 1881–1955

Fernand Léger first trained as an architect. He loved busy cities and was fascinated by the smooth shapes and shiny surfaces of modern machine parts. He simplified what he saw into geometric forms, often so cylindrical that some people call him a 'tubist' rather than a Cubist!

Léger studied and admired the modern industrial world. He learnt more about the machine age when he fought in the First World War, and after his release from the army in 1917 he carried on painting the changing world around him. Later Léger created theatre sets, and even made a film.

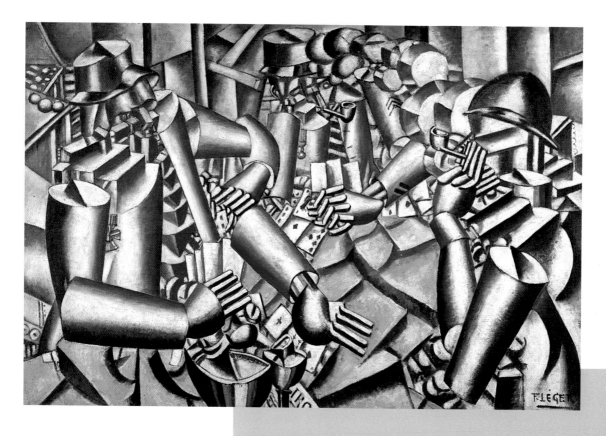

Soldiers Playing Cards

1917, oil paint on canvas

Léger's cardplayers are like robots. They have cuboid fingers on cone-shaped hands, which seem to rotate on cylindrical arms. Their spines are built up from jointed angular blocks, like pointed chunks of metal. Everything in the painting looks as if it could be part of a machine. But Léger reminds us that these are human figures by showing them smoking pipes and playing cards. Repeated shapes give the scene a sense of movement, reflecting the lively, jostling action of the game.

The Town
1919, oil paint on canvas

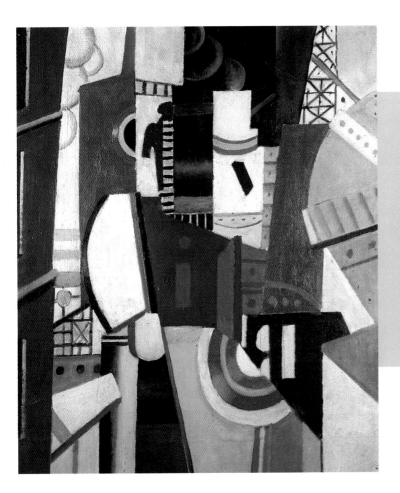

This is an imaginative view of a busy town. Léger has painted elements of the modern world in a modern way. We can see the criss-cross grid shape of a pylon in the top right hand corner, and what looks like a factory, bottom left. Clouds of smoke, like transparent bubbles, seem to emerge from a white funnel in the centre. The shape running up the left side of the picture looks like the edge of a tall building. It's as though we're looking down at the town from the window of an upper storey.

MODERN IDEAL
Léger's art shows his idea of a modern mechanical paradise. Look around you for architecture and machinery that you find interesting and new. Try painting a city scene in Léger's Cubist style.

Tug Boats
1920, oil paint on canvas

We can't immediately see Léger's boats. The things that first catch our eye are three figures, a ladder and a dog. Around them are abstract shapes which all have something to do with boats in a port. The tubes remind us of funnels, the circles of portholes. Léger hasn't painted a view of tugs in a sea port, but a collection of shapes that echo the geometric forms of the boats and rigs.

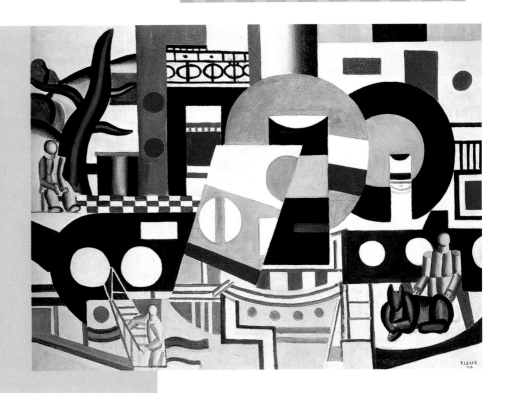

JUAN GRIS 1887–1927

'I try to make abstract things become real.'

Like Picasso, Juan Gris was born in Spain. He began working as a magazine illustrator in Madrid before moving to Paris where he continued making humorous pictures for political journals. After seeing the work of Picasso and Braque, he took up painting and worked in the Cubist style.

Gris was interested in science and engineering and his paintings show this in their carefully structured compositions. He built up images from abstract shapes, and often used collage to help him achieve different effects. Many other Cubists were inspired by his ideas.

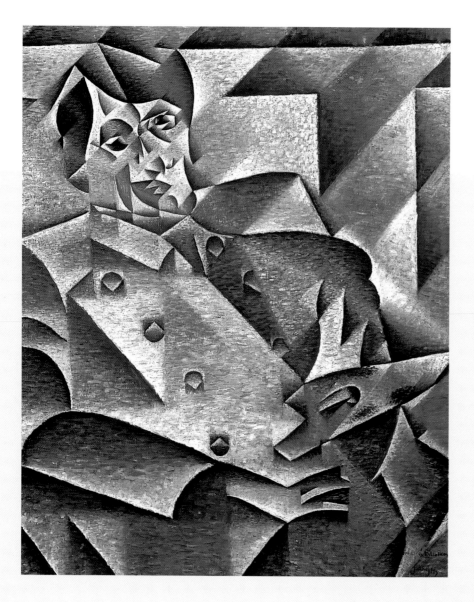

Portrait of Picasso

1912, oil paint on canvas

Gris lived near Picasso in Paris, where he painted this portrait. Through the maze of geometric shapes you can just make out the figure of Picasso, seated in a chair. You can't see his features clearly enough to recognize his face. Is that an artist's palette he holds in his hand? The image is made up of many different pieces, all of them shaded as if they were separate forms. The effect is like that of a photo taken by a shaking hand. It gives a feeling of life and movement.

Still life (Fantomas)
1915, oil paint on canvas

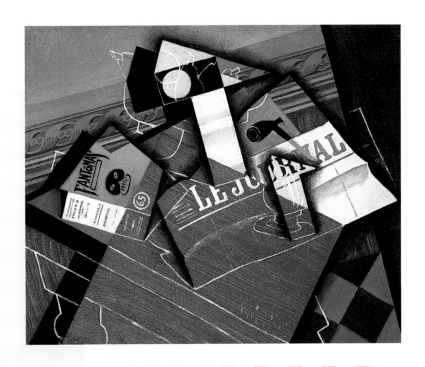

We can recognize a number of objects in this painting, but it's difficult to make sense of them. We can pick out a paperback thriller with the title *Fantomas*, a pipe, a newspaper, a table top and a tiled floor. All these objects appear fragmented. They also look unreal. Parts of some things seem invisible. Can you see the wine glass, fruit and table leg painted over the newspaper and wooden panel? Their outline is ghostly, as the title of the painting suggests.

STILL LIFE LAYERS
You can make up a still life like *Fantomas* by using collage. Collect some interesting objects and arrange them on a table. Then build up a picture of your setup, using shapes torn from newspapers, magazines and wrapping paper. Try putting them together in unusual ways.

Landscape at Ceret
1913, oil paint on canvas

Here we see a bright landscape, but not in its complete form. The impression we get is of a poster that has been cut up and rearranged. Gris has put together different viewpoints on the same plane. He shows us roof tiles seen from above, and walls and trees from the side. Intense, bright colours suggest the blazing heat of the sun. Everything is simplified and fragmented. It's like a memory of the place.

ROBERT DELAUNAY 1885–1941

'I wanted to put different sides next to each other.'

Robert Delaunay was born in Paris. He trained there as a decorative artist before becoming a painter. Delaunay loved the colour and speed of modern city life. He wanted to paint this energy and not simply show what the streets looked like.

Delaunay's art is based on colour, light, rhythm and movement. He wanted his paintings to make music for the eyes. One of his friends, the poet Apollinaire, named his style Orphic Cubism. He described Delaunay's imaginative work as pure art.

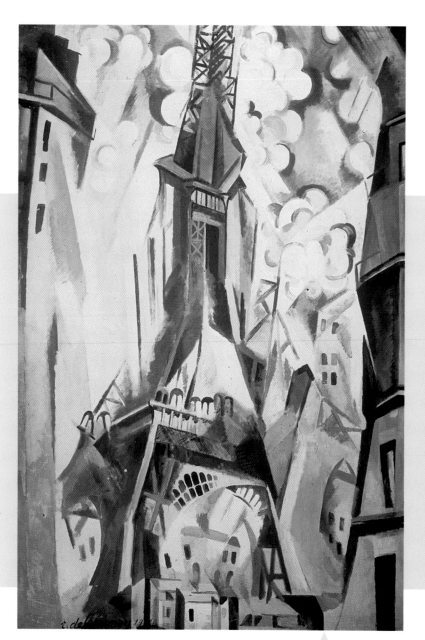

The Eiffel Tower
1910, oil paint on canvas

Delaunay painted the Eiffel Tower about 30 times. This great Paris landmark was built in 1889 to celebrate an important exhibition in Paris. It was a symbol of the triumph of modern engineering and soon became an emblem of France itself. Delaunay admired the eye-catching structure of the Eiffel Tower. Here he gives us a sense of the excitement he felt when he saw it. The bright light, vivid colours and fragmented forms suggest energy and life. The Tower itself almost seems to be leaping around!

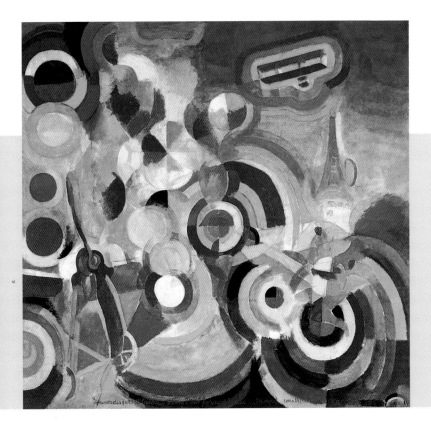

Homage to Blériot

1914, oil paint on canvas

Blériot was the first man to fly across the water from France to England. You can just make out a propeller on the right of this painting, and above it a biplane drifting past the Eiffel Tower. Propeller shapes are repeated throughout the image, as are coloured discs. Delaunay saw these discs as symbols of the energy and light he associated with the fast-changing modern world.

FEEL THE COLOUR

Delaunay used colour to express different feelings. Find a scene that's easy to paint, then make several pictures of it using various colour schemes. Try reds and yellows, then blues and greens, then browns and greys. See how this changes the mood of your scene.

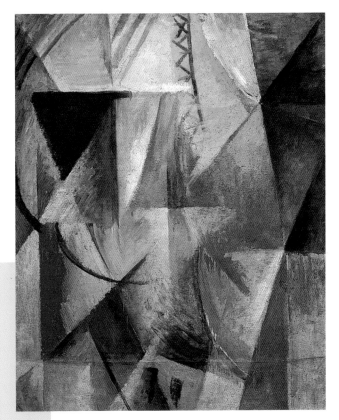

This is one of a series of paintings that Delaunay made of the same subject. The title suggests that it's a view seen through a window. In fact Delaunay took the image from a postcard of the Eiffel Tower, as seen from the Arc de Triomphe. When you look closely you can just make out the tower's form, but it seems to be dissolved in a mass of coloured shapes. Delaunay shows us hints of buildings, but they don't look solid. Light and colour take over, giving an impression of Paris, not a realistic scene.

Window: Study for Two Windows

1912, oil paint on canvas

17

ALBERT GLEIZES 1881–1953

Albert Gleizes was born in Paris. He worked as an industrial designer before becoming a painter. Influenced by Braque and Picasso, he began not only to paint in the Cubist style, but also to write about it. Along with his friend Metzinger, he published *Cubism*, a book explaining what the Cubists were trying to do.

After serving in the army during the war, Gleizes travelled to America where he showed his work. He loved the buzz of the cities there. He then toured Spain and Portugal before returning to Paris where he became a mural painter.

Landscape

1911, oil paint on canvas

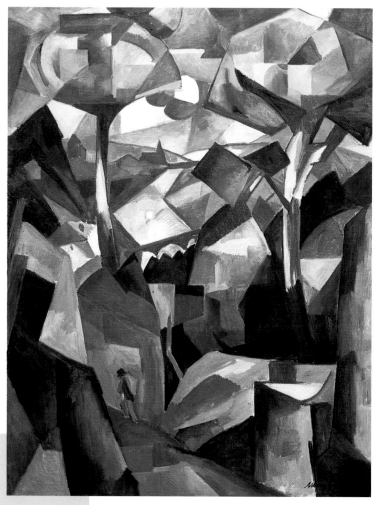

Here we see a grey figure who seems to step from a path into a landscape made up of angular shapes. The path bears left and winds away into the background, but the rest of the painting does not give us a clear sense of things going back in space. Trees, buildings and clouds are painted as overlapping shapes. Gleizes does not use the traditional system of perspective to make us think we're looking into the distance. After the invention of photography, artists were no longer particularly interested in tricking the eye. Here there is no horizon separating the sky from the land, and no point at which things seem to vanish from sight.

MIND'S EYE

The Cubists didn't try to copy exactly what they saw – they painted what was in their mind's eye. Try making a picture of a person or place from memory. Emphasize the details that stand out most in your mind.

The Bridges of Paris

1912, oil paint on canvas

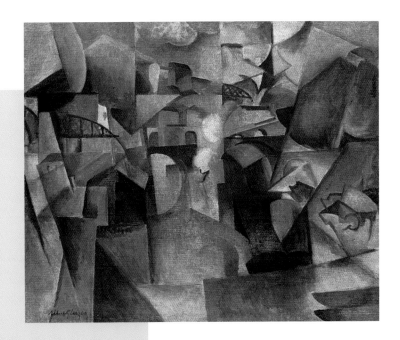

Like many Cubist landcapes, this painting looks like it has been rearranged from a cut up picture. The bridges, which are usually seen in line along the River Seine, appear here in fragmented pieces, dotted around the scene. You can see some arches among buildings and streets, clouds and trees. It's hard to tell whether you're looking at the bridges from the river or from the land.

The Clowns

1917, oil paint on canvas

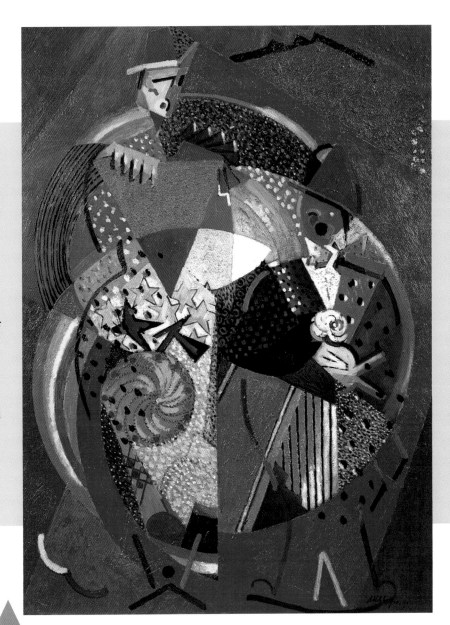

In this bright and lively painting, the forms of two clowns can be seen amid a swirl of intersecting circles. These spiralling shapes remind us of cartwheels and somersaults – the acrobatics that clowns might perform in a circus ring. Gleizes creates a sense of movement, especially of things spinning. The central part of the painting seems to rotate in a whirlwind of solid colour. By contrast, the clowns' legs and feet are shown in broken outline. This suggests they are static, but may be about to move.

19

JEAN METZINGER 1883–1956

'The only real Cubist in the proper sense.'

Jean Metzinger was born in Nantes in France. After moving to Paris he met the other Cubists, and often visited Picasso's studio. He showed his paintings in Cubist exhibitions, and together with Gleizes was the first to write on the movement.

As well as the book *Cubism*, Metzinger published many articles on modern painting in magazines. After serving in the army in the First World War he returned to work in Paris. His paintings are full of flat, geometric shapes, often in bright colours.

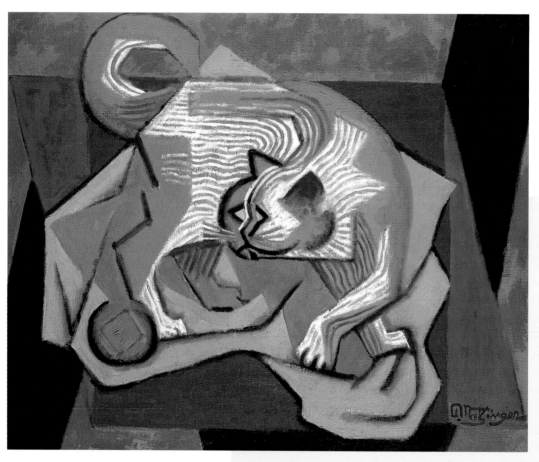

The Cat

1915, oil paint on canvas

In this painting we see the cat's face from the side and front at the same time. It makes us feel the animal is moving its head, turning to play with the ball of wool by its back paw. The shape of the cat has been simplified. Its back leg has a zigzag outline, making us feel it is bending in a quick, agile movement. The angular grey shadow behind it suggests that the leg has just moved from this space. Metzinger has simplified colours, tones and textures so that the image looks flat. The pattern-like effect reminds us of a mosaic.

Tea Time

1911, oil paint on cardboard

Here we can clearly see a woman sitting at a table, with one hand holding a spoon and the other touching a cup and saucer. The cup and saucer are sliced in two, and each half is seen from a different angle. In a similar way we see one of the woman's eyes from the front, and the other from the side. The background seems to cut into her right shoulder. Metzinger is reminding us that when we move around we see objects from many different viewpoints.

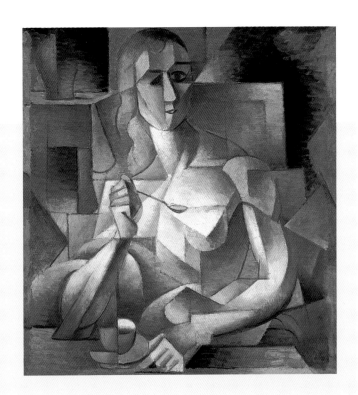

The Knitter

1919, oil paint on canvas

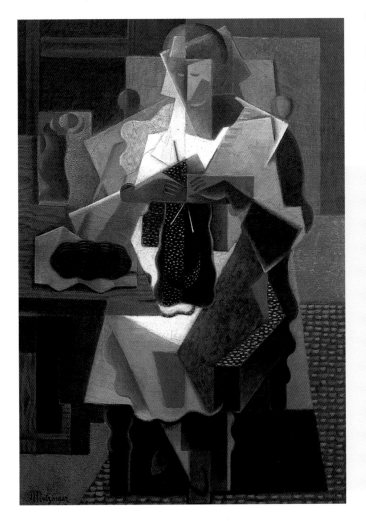

MIXED VIEWS

Metzinger painted his figures as if looking at them from several viewpoints at once. Draw a face from the front, then, on top of it, draw a side view in another colour. In a third colour, draw the face from the other side. What effect does this create?

The knitter in this painting is easily recognizable. We can clearly see her hands and the needles she is holding, even though they are made up from geometric forms, Her face is also well defined, though it's not realistic. The woman's body is not so easy to make out. When you look for her outline, it seems to merge with the chair she's sitting on and the table that holds her ball of wool. Metzinger has built up this image from a series of flat, overlapping shapes. The pieces almost look like cards that have been slashed and slotted together at different angles.

ROGER DE LA FRESNAYE 1885–1925

'Each object gradually becomes part of the painting.'

Roger de la Fresnaye showed great artistic talent from boyhood. Around 1910 he met some of the Cubists, and adopted their art style.

La Fresnaye used angular geometric shapes in his work, but his images are often more naturalistic and easier to make out than many Cubist works.

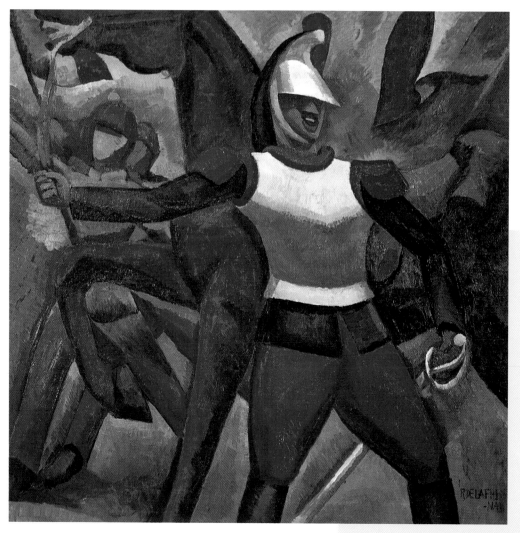

Le Cuirassier

1910–11, oil paint on canvas

The dramatic shape of the soldier stretches right across this huge painting, from top to bottom and from left to right. The power of the armed warrior is emphasized by the control he shows over his straining horse, whose reins he clasps in his right hand. The background is not so clear – it seems to disappear into a series of grey planes, but we can just see the red helmets of two soldiers, one of whom carries the French flag.

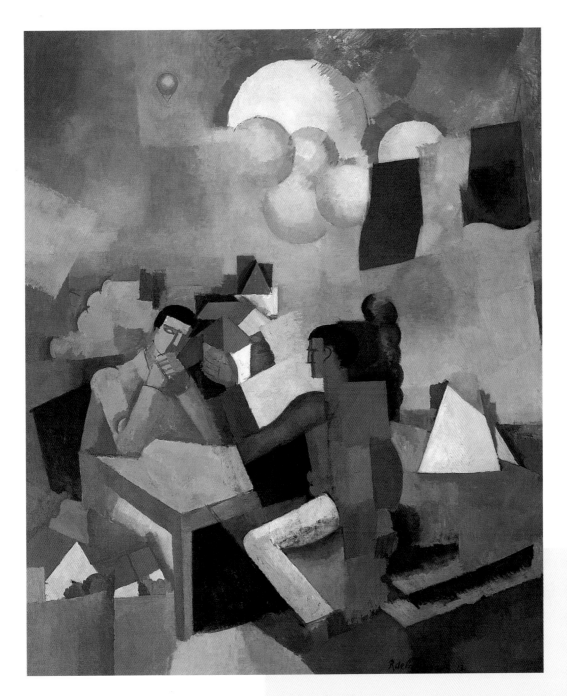

The Conquest of the Air

1913, oil paint on canvas

HISTORIC MOMENTS
La Fresnaye chose heroic subjects for his paintings. Aeroplane flight was a bold new venture in his time. What would you choose to paint as a ground-breaking theme today?

This painting shows a self portrait of the artist chatting to his brother Henri. Perhaps they are talking about the conquest of the air suggested in the title. The French Montgolfier brothers had been the first to take to the skies in their hot air balloon of 1783, but the Wright brothers of USA had much more recently flown the first powered plane. Flight was to play an important part in the future of modern transport. Henri was himself the director of an aeroplane factory. Here he seems almost to have his head in the clouds, as if dreaming of what he might one day achieve.

MARCEL DUCHAMP 1887–1968

'We paint because we want to be free.'

Marcel Duchamp was born in France. He was one of six children, four of whom became famous artists. His eldest brother Gaston was another Cubist, known as Jacques Villon (see pages 26–27).

Marcel first trained as a librarian and then as an illustrator before becoming a painter. He experimented with a number of styles, including Cubism, and soon turned his back completely on traditional painting. Duchamp was a true revolutionary in the art world.

'An explosion in a shingle factory' was how one critic described this painting when he saw it exhibited at the Armory Show in New York. The flurry of angular brown shapes was quite unlike anything anyone had seen before. If you look closely, you can see how Duchamp learnt from Muybridge's photographs of people moving (see page 6). He has painted a figure rushing down stairs by showing every stage of the movement. We can't see the figure clearly, but the repeated forms make us feel its speed.

Nude Descending a Staircase No 2

1912, oil paint on canvas

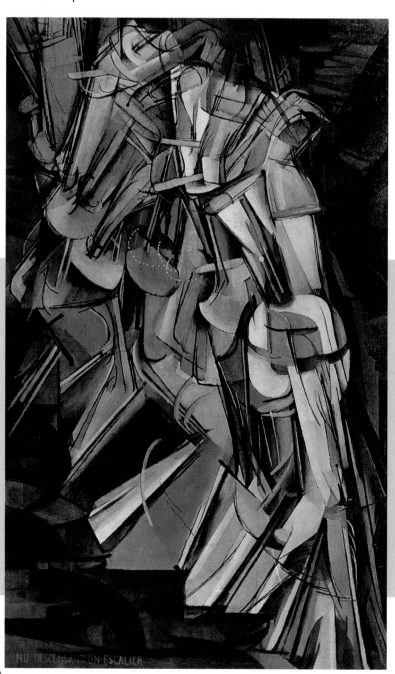

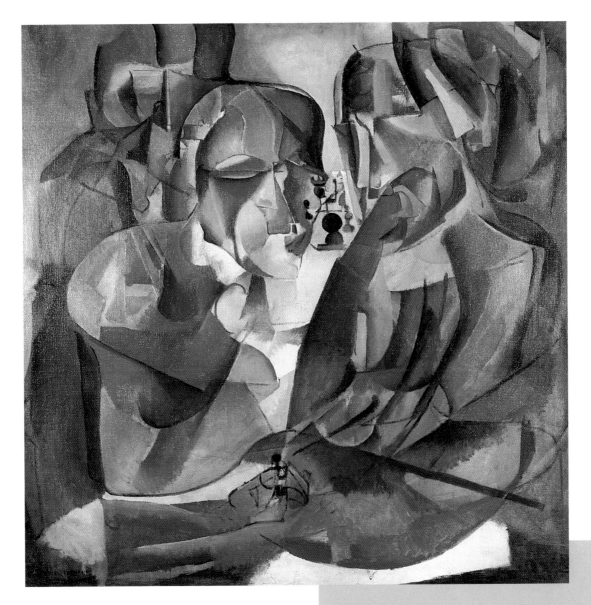

Portrait of Chess Players

1911, oil paint on canvas

Marcel Duchamp was a keen chess player. Here he shows two figures playing a game. They are not visible immediately as their forms have been fragmented into pieces, shaded in pale ochres and soft browns that merge together in a confusing way. But if you look closely you can see that the figure on the right is resting an arm on a table and a hand against his chin. The other player holds a pawn. Between the heads of the two figures we can see more chess pieces. It's as though the two players are thinking of their next move.

CAPTURE A MOVEMENT

Try recreating a figure in motion in the same way that Duchamp did. Take a series of photos of a person or animal as it moves. Lay the photos next to each other so that the images overlap. Make a drawing or collage of the shapes and patterns you see.

JACQUES VILLON 1875–1963

Like his brother, Marcel Duchamp, Jacques Villon worked as an illustrator before turning to fine art. He was a great thinker and loved maths, which he saw as the base for Cubist art.

Villon formed a group of artists called the *Section d'Or*, who met in his studio to talk about art and showed their work together. These included Léger, Delaunay, Duchamp, Gris, Gleizes and Metzinger.

Young Woman

1912, oil paint on canvas

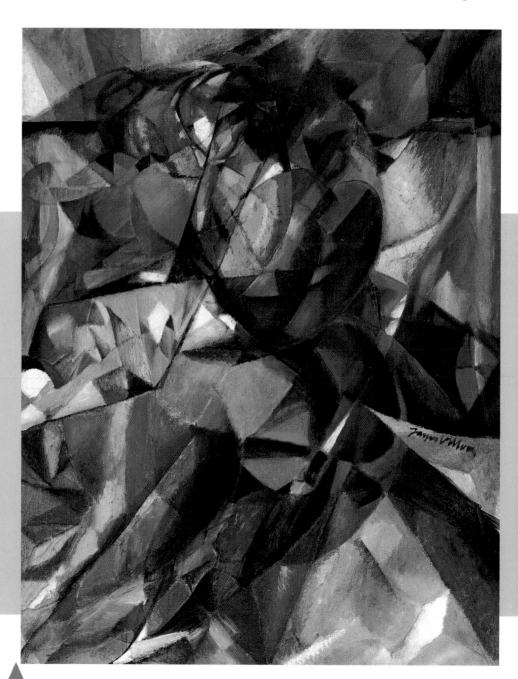

The artist's signature is the only element which we can clearly distinguish in this picture. Everything else seems to disintegrate. We can only tell from the title that this is a young woman. Once we know the subject, we have to search the mass of shapes to try to make it out. Everything, including the space surrounding the woman, is splintered into bright geometric shapes. It's a dazzling effect!

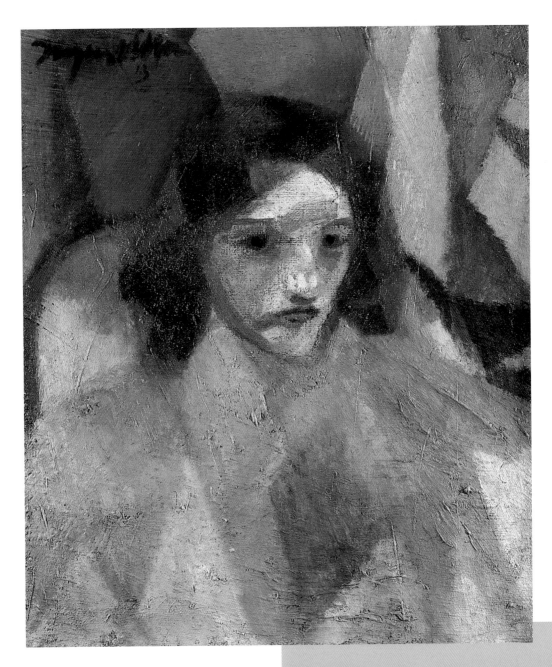

A Woman

1913, oil paint on canvas

DIFFERENT FACES
These paintings show the human form in two quite different ways. Choose a person you'd like to study and find as many pictures of them as you can. See how you can change the images by cutting them up or painting on them.

By contrast to the last painting, we can easily tell that this is a portrait – the woman's face has clear features, and we can make out the back of the chair she is sitting on. But this is still very much a Cubist image. The geometric shapes of the background cut into the girl's hair and her clothes are painted in an angular diamond pattern. Her head is dashed with green triangles and her body seems flat and formless. Villon has played with colour and shape in an unusual but well-balanced way.

Artists in many countries quickly became interested in Cubism. Often their art was given a different name. In Italy, for instance, it was known as Futurism and in Russia Constructivism. These are just a few examples of the spread of the Cubist style.

GINO SEVERINI
Blue Dancer

1912, oil paint on canvas

Severini was an Italian Futurist. He loved the speed of the modern world. This painting of a dancer in a blue dress is lively and energetic. Forms are fragmented and repeated to give a feeling of rhythm and rapid movement.

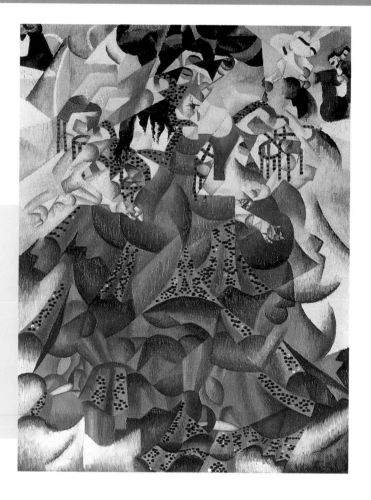

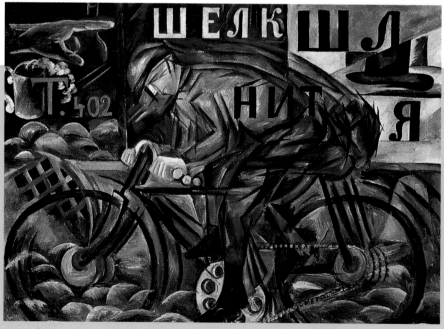

NATALIA GONCHAROVA
The Cyclist

1913, oil paint on canvas

This cyclist, painted by a Russian artist, seems almost transparent. He merges with lettering on roadside posters and cobbles on the street, as though he's whizzing by.

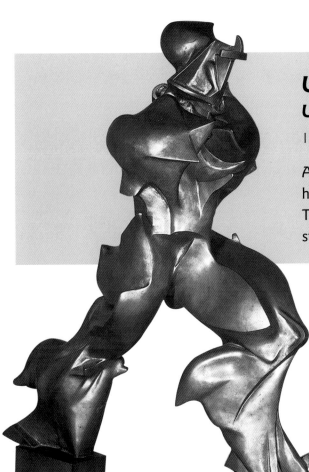

UMBERTO BOCCIONI
Unique Forms of Continuity in Space

1913, bronze

As well as being a painter, the Italian Boccioni showed how Cubism could be translated into three dimensions. This sculpture looks like a shiny, modern, metallic robot striding smoothly and powerfully through space.

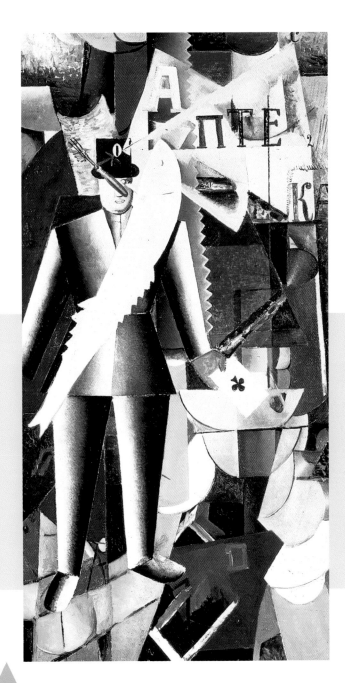

KASIMIR MALEVICH
The Aviator

1914, oil paint on canvas

This Russian painting shows an aviator with a tubular metallic body which reminds us of Léger's art. Surrounding the figure are cuboid shapes and snippets of the modern world, from smoky factory chimneys to jagged blades and machine parts. The playing card in the man's hand and random lettering in the background add a mysterious air to the scene.

abstract A word describing art that we can't easily recognize, identify or relate to.

Armory Show A big modern art exhibition held in New York in 1913. It featured the work of many Cubists, spreading the style to America.

biplane An early type of aeroplane with two sets of wings, one above the other.

canvas A strong fabric which artists paint on.

collage A collection of materials, such as paper, fabric and photos, stuck on to a background.

composition The way a work of art is arranged.

Constructivism An art movement in Russia that was influenced by the Cubist style. The Constructivists were interested in geometric shapes. Often their work is quite abstract.

fine art Art that is not made for any practical purpose or to convey any functional message.

First World War The war that raged in Europe from 1914 to 1918.

fragmented Broken into many pieces.

Futurism An art movement in Italy that was influenced by Cubism. Like the Cubists, the Futurists were interested in the machine age and the city, and particulary in dynamic movement.

harlequin A comic theatrical character, usually depicted wearing diamond-patterned tights and a black mask. Harlequins appeared many times in Cubist paintings because of their geometric forms.

image A picture or idea.

industrial designer Someone who designs products to be manufactured in a factory.

movement A style or period of art.

mural A wall painting.

naturalistic Realistic or true to nature.

Orphic Cubism A term invented by the poet Apollinaire to describe the colourful, almost abstract Cubism developed by Delaunay.

perspective A system used in painting and drawing to create an illusion of depth and space. When something is drawn in perspective it appears to recede into the distance.

plane A flat surface.

retrospective Looking backwards. A retrospective exhibition looks back on an artist's life's work, usually after their death.

Section d'Or Translated into English, *Section d'Or* means Golden Section. As well as describing the circle of artists led by Jacques Villon, it was also the name of a magazine produced by the group and an exhibition of their work in 1912.

self portrait An image an artist makes of him/herself.

still life An arrangement of objects that don't move, such as fruit, flowers or bottles.

studio An artist's workplace.

CUBIST TIMES

1895 First motion-picture shown in Paris cinema by Lumière Brothers.

1903 First manned plane flight achieved by Wright Brothers, USA.

1906 Death of Paul Cézanne.

1907 Retrospective exhibition of Cézanne's paintings impresses many artists. Picasso studies African masks for first time. He paints *Demoiselles d'Avignon*.

1908 Art critic Louis Vauxcelles coins phrase Cubism to describe Georges Braque's landscapes.

1909 Frenchman Louis Blériot makes first flight across English Channel.

1912 *Section d'Or* group established. Members include Gleizes, Gris, La Fresnaye, Léger, Metzinger and Villon. First Cubist exhibition in Paris. Gleizes and Metzinger publish book *Cubism*, soon to be popular throughout Europe.

1914 Outbreak of First World War. Braque, Gleizes, La Fresnaye, Léger and Metzinger all serve. Turning point in Cubist movement.

1918 End of First World War.

FURTHER INFORMATION

Galleries to visit

There are many places where original Cubist paintings can be seen. Some of the largest collections are in America. The **Museum of Modern Art**, New York, houses Picasso's *Demoiselles d'Avignon* and many more, and the **Philadelphia Museum of Art** also has a number of examples. In Paris, France, where Cubism was born, the **Musée Picasso** is dedicated to this revolutionary artist.

In the UK, the **Tate Gallery of Modern Art**, London, has many Cubist works, particularly by Picasso and Braque. The **Estorick Collection**, London, has a small but fine gallery of paintings by the Italian Futurists.

Websites to browse

http://sunsite.org.uk/wm/paint/tl/20th/cubism/html
http://www.salford.ac.uk/modlang/ote/aditi/modart/html
htp://www.stockportmbe.gov.uk/pages

Books to read

Cézanne by Mike Venezia, from the *Getting to Know the World's Greatest Artists and Composers* series, Watts, 1994 (also a title on *Picasso*)

Cézanne from A to Z by Marie Sellier, Peter Bedrick Books, 1996

Picasso by Stefano Loria, from the *Masters of Art* series, Macdonald Young Books, 1995

Picasso, Breaking the Rules of Art by David Spence, from the *Great Artists* series, ticktock Publishing Ltd, 1997

Understanding Modern Art by Monica Bohm-Duchen and Janet Cook, Usborne, 1991

What Makes a Picasso a Picasso? by Richard Mühlberger, Cherrytree Books/ Metropolitan Museum of Art, 1994

INDEX